THE CITY OUT MY WINDOW

63 VIEWS ON NEW YORK

MATTEO PERICOLI

INTRODUCTION BY PAUL GOLDBERGER

THE CITY OUT MY WINDOW

63 VIEWS ON NEW YORK

MATTEO PERICOLI

INTRODUCTION BY PAUL GOLDBERGER

SIMON & SCHUSTER

New York London Toronto Sydney

SIMON & SCHUSTER
1230 Avenue of the Americas
New York, NY 10020

First Simon & Schuster hardcover edition November 2009

SIMON & SCHUSTER and colophon are registered trademarks of Simon & Schuster, Inc.

For information about special discounts for bulk purchases,
please contact Simon & Schuster Special Sales at
1-866-506-1949 or business@simonandschuster.com.

The Simon & Schuster Speakers Bureau can bring authors
to your live event. For more information or to book an event
contact the Simon & Schuster Speakers Bureau at
1-866-248-3049 or visit our website at www.simonspeakers.com.

Book concept by Matteo Pericoli

Designed by Suet Y. Chong and Kyoko Watanabe

On the cover: Saul Steinberg's window view

Manufactured in China

1 3 5 7 9 10 8 6 4 2

Library of Congress Cataloging-in-Publication Data
Pericoli, Matteo.
The city out my window : 63 views on New York / Matteo Pericoli.
p. cm.
1. Pericoli, Matteo, 1968– —Themes, motives. 2. New York (N.Y.)—In art.
3. Windows in art. I. Title.
NC257.P429A4 2009
704.9'44747—dc22 2009007279

ISBN 978-1-4165-6990-9
ISBN 978-1-4165-7026-4 (ebook)

CONTENTS

INTRODUCTION

Paul Goldberger

You would think that anyone who would try to draw all of Manhattan Island on a seventy-foot-long scroll, as Matteo Pericoli did for his remarkable *Manhattan Unfurled*, would be someone who preferred the big picture. It is not quite true, however. The key to *Manhattan Unfurled* isn't the vastness of its scope, but the intimacy of its vision. The magic of Matteo Pericoli's delicate line drawing of the entire Manhattan waterfront is how he turns the gigantic city into something gentle and personal. Now, in *The City Out My Window*, he reveals what I suspect has motivated him all along: the personal connection each of us has to the cityscape, and the way in which things that are simply there, things that we did not create but that we look at all the time, can have a profound effect on our being.

What is less in our control than a city view? We can choose not to live somewhere, but that is about as far as most of us can go in determining what we look at from our windows. Once we move in, we are captives of what is outside the window, whether it is an expanse of skyline, an array of rooftops, a sliver of green, or—as was the case for me in an apartment I lived in briefly long ago—a dark air shaft. A view is like a mate: you must be sure you want to live with it, because you cannot really change it. And you have to be prepared for the fact that it may change of its own accord.

But once you accept it, it becomes a part of you, and what you see in it tells everything. The sixty-three New Yorkers whose views Matteo Pericoli has drawn here are different people who live different lives in different places, and it goes without saying that the views from their windows are as different as they are. But when they talk to Pericoli about what they see, they inevitably reveal as much about themselves as they do about whatever happens to lie outside their windows. The writer Peter Carey sees the history of his neighborhood

more than whatever is out there now; Derek Bermel, a composer, talks only of the sounds he hears when he looks out the window. Carroll Bogert, a human rights activist, says she looks at the sky and thinks of places far away. David Byrne, the musician, thinks of the people he is looking at, and of other people looking at him. The neurologist and writer Oliver Sacks talks of how some of the things he sees are calming, and others are stimulating. The editor and writer Ben Sonnenberg is made angry by his glimpse of Donald Trump's buildings and gratified by the Hudson River and sunsets. The writer Gay Talese tells a story, naturally—about why he does not employ window washers and so sees his view through the haze of city soot—and the writer and professor Alexander Stille grumbles that he has too much view and too much sun and that he needs to cover up his view if he is to get anything done.

I understand that. I was sufficiently traumatized by my early experience with the air shaft to move to an apartment with windows that look into the trees of Central Park, and while I love the fact that my view is lush and green in the summer, orange in the fall, and thin and almost colorless in the winter and spring—never before have I been so conscious of seasons in the city—I set my desk to have my back to this view, since if I had to look at it all the time I know I would get nothing done because I knew it would distract me, or worse, eventually I'd stop noticing it. This way when I get up and walk to the window, looking out becomes an event. A view should not be wallpaper.

It is remarkable how few of Pericoli's subjects talk about seeing other people out the window, which suggests either that their minds are elsewhere or that people in New York are not as exposed to public view as you would think. There are no *Rear Window* tales here—the closest these people seem to come to noticing activities that weren't intended for their eyes is the editor Lorin Stein seeing (and hearing) his neighbor singing, and the choreographer Mark Morris's report on his neighbors having sex.

Is a city dwelling a perch, a vantage point from which to view the world? Or is it a cave, an escape? Is the view from the window something to connect you to what you see, or something to inspire you to contemplation? Ideally it is some of both, and allows you to face both outward and inward. In between the air shaft and the trees, I lived in an apartment with a sunroom set into a corner, overlooking rooftops. It wasn't a very high floor, but since the sunroom looked over all the brownstones and consisted mostly of windows, it felt

like being in a hovering helicopter, which is probably why I experienced it only in terms of looking out, and paid little attention to the fact that I was probably very visible in that room.

Every one of these exquisite drawings and every one of these statements is, to some extent, a comment about privacy, and the tension between public and private life that is an essential element of city existence. Lewis Mumford once referred to the city as "a stage upon which the drama of social life may be enacted, with the actors taking their turns as spectators, and the spectators as actors," and while he was thinking of the life of the street, he could well have been talking about the way so many of us look out the window and know that we are being looked upon at the same time. My kitchen looks across a courtyard to another kitchen, and for months after a new neighbor and his family moved in, I noticed them observing me and my family, first by pretending not to be looking at all, and then with occasional waves as we tacitly acknowledged one another. One day I met the man on the street, and he started talking to me as if we already knew each other, which, in a sense, we did.

If the not-so-hidden subtext of this book is a rumination, or a series of ruminations, on the inner thoughts people have about the place they live in and how it relates to the world, *The City Out My Window* is also, of course, a kind of primer in miniature about urban architecture. It is striking how much Matteo Pericoli's simple lines tell us about the design of each dwelling here, and not only about the physical world that lies beyond it. You can see that Kurt Andersen lives in a brownstone on a beautiful street, and that Roger Angell and Graydon Carter have offices in a new midtown skyscraper (the same one, in fact, though they have views out different sides), and that Nora Ephron lives in an elegant older apartment building, and that Mark Morris lives in a newer one. You can see how much the architecture of a window sets a tone. (For all that Pericoli's drawings pull your eye out through the window, your mind also turns the other way and tries to imagine what the interior of these rooms must be like.)

You lose that pleasing counterpoint between architecture and view if your view is through one of those big windows with single panes of glass, windows that are called picture windows but which, paradoxically, make the picture less interesting by removing that subtle tension between the architecture of the building you are in and the view of the

world outside. Most of the views in this book are seen through double-hung windows, which divide the view into two halves, top and bottom, but your eye puts it all together into one composition, and the horizontal line across the middle of the view is but a punctuation mark. Your eye does the same thing if you are looking through casements or windows with multiple panes, but all those lines are a stronger presence and inevitably make you more conscious of the architecture. In places like that, the window becomes a more conspicuous object in itself, but the trade-off is how, as in Stefan Sagmeister's view, or Mikhail Baryshnikov's, there is a lovely interplay between the pattern of the window in the foreground and the drama of the view in the background. You see lines, then your eye makes the lines recede, and you see the city. The same thing happens if a window is oddly shaped, like the arched windows of The Cloisters through which Peter Barnet views the George Washington Bridge: you see the shape first, and then it gives way to the view.

Not the least of the lessons of this book is how important it is to feel one's house as an enclosure, and how an entirely wide-open view loses something by not being confined a bit by architecture. Matteo Pericoli might have titled this book *Your Window Is Your Frame*, since that is what it is telling us—that your window is the frame through which you see your own picture of the world, a picture that is yours and no one else's.

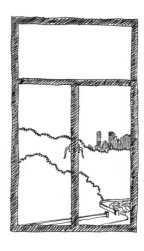

SKETCH OF PAUL'S VIEW

THE CITY OUT
MY WINDOW

"The view includes everything I require in an everyday view: sky, trees, gardens, people walking by on the sidewalk. And the several brownstones across the street are more or less mirror images of our own, which indulges my vanity in a sort of reassuring gemütlich way."

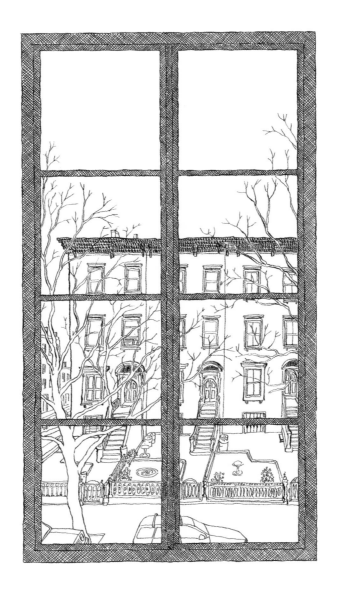

KURT ANDERSEN

"My view, for all its architectural dreariness, is constantly altering, thanks to the reflected sunlight, bouncing off hundreds of different windows, that pours in here later on in the day. In the winter, the sun has slid away by late afternoon, and in the next hour or so the pink and orange and green and blue and silver hues and the garishly urgent messages and the moving downtown taxi headlights of Times Square (or at least a narrow strip of it) will come rising into view from the lower left of my window, telling me that it's okay to go home again."

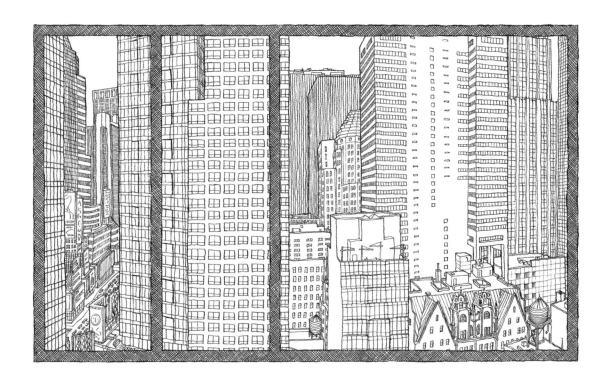

ROGER ANGELL

"The steel span of the George Washington Bridge, on the right, was beloved by Le Corbusier, who called it the most beautiful bridge in the world. The bridge was dedicated in 1931, seven years before The Cloisters opened its treasures to the public in a building comprised of medieval architectural elements transported from France and Spain. My office atop the tower at The Cloisters, the branch of the Metropolitan Museum of Art dedicated to medieval art, has spectacular views in four directions. Here, we look south through a pair of Romanesque-style windows across the terra-cotta roof tiles to Fort Tryon Park and the Hudson River. The west windows overlook the river and the unspoiled Palisades, and on a clear day the view north extends to the Tappan Zee Bridge. Only the view east over the Harlem River and the Bronx takes in the densely built contemporary city."

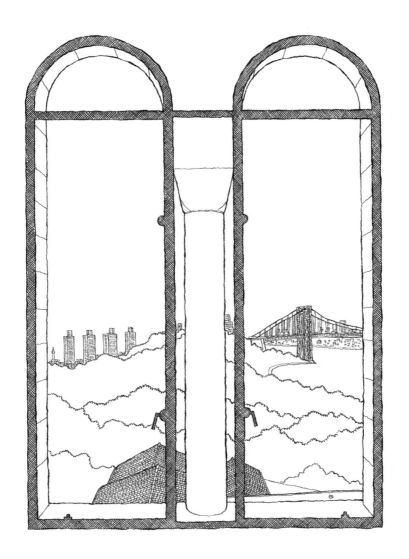

PETER BARNET

"Rather than looking at my view, I feel that I exist within it, like living in a pop-up book of New York City. Broadway, Duke Ellington Boulevard, and West End all converge on our corner, creating an atmosphere reminiscent of the big avenues in Paris. When I wake up, before doing anything else, I peek behind the shade, gaze down Broadway, and take in the sounds and sights of the city. My husband, children, and I share my view—whether we are waving at each other from the inside out or imagining the lives of the people who pass under us—the window provides a structure through which we can dream (and prepare for the weather!)."

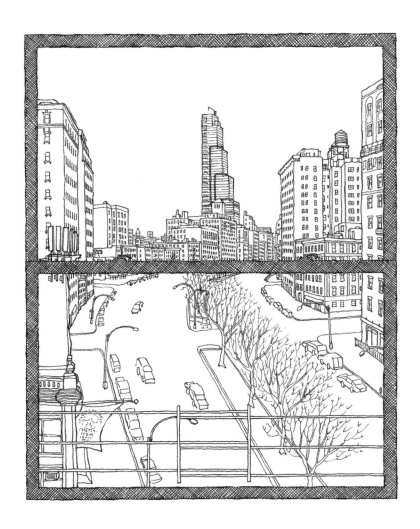

CAROLINE BARON

"It's one of New York's most beautiful buildings, but it looks better at night . . . like a woman."

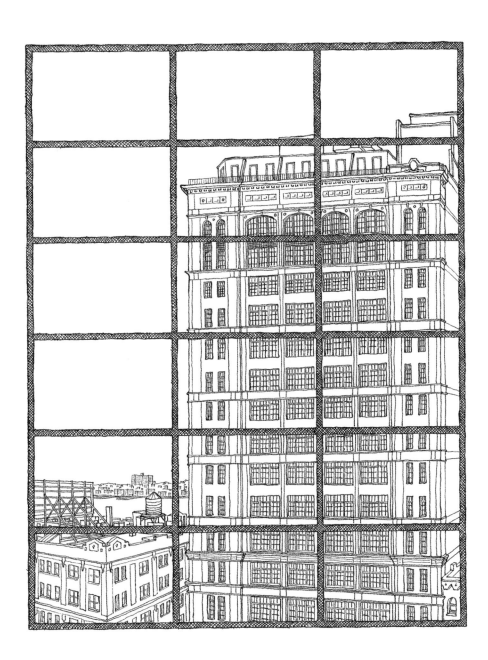

MIKHAIL BARYSHNIKOV

"Out our window the view toward Washington Square is the entire history of mid-twentieth-century pop culture . . . around the corner to the Cedar Tavern of Pollock and de Kooning, NYU, Bob Dylan and Jimi Hendrix, Allen Ginsberg and the Beats, Ninth Street to Christopher and the Stonewall Revolution; the world as we know it is born here, lives here, will evolve here. It is beauty, it is paradise, it is frenetic and calm. Ahh, my park has a new face now and the damn fountain is finally at rest where it should be."

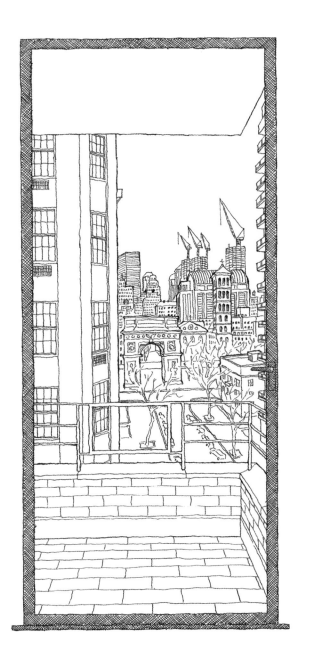

MARIO BATALI

"I look out at dozens of neighbors who live in apartment buildings, town houses, and even an artist's atelier, but I cannot see them with the naked eye. I am content to leave to my imagination exactly who they are and what they do. Peering at them up close through a telescope would not only breach an unwritten code of urban ethics, it would probably reveal their lives to be far less glamorous than I like to think they are."

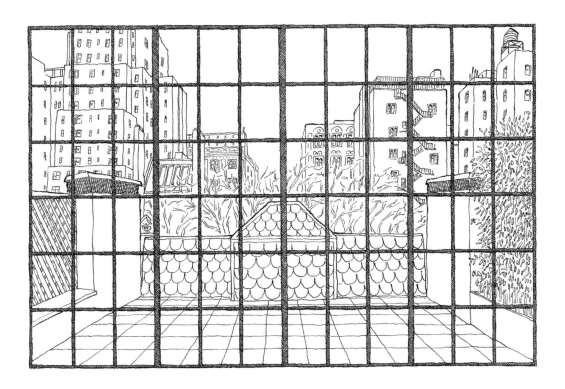

JOHN BERENDT

"At dawn, a mockingbird; in the morning, a chugging truck unloading parcels; at noon, the television downstairs; in the afternoon, muffled shouts from kids playing next door; at dusk, a car alarm; at night, police sirens; then stillness."

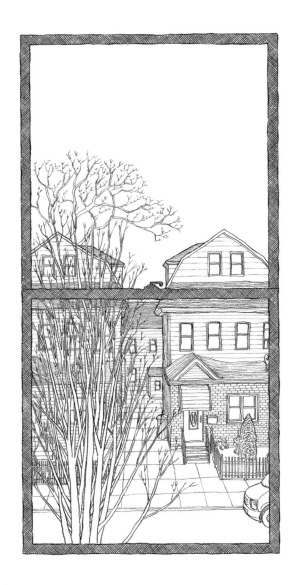

DEREK BERMEL

"When I look out the window in Jackson Heights, I notice the facades, flatter than their counterparts in Manhattan, or so they seem to me. The buildings here are less baroque. Their protuberances are fewer and I am forced to appreciate the details of the surface, to let my eyes linger on the nuances of a door frame or molding corner or cheap brick step. The horizontals are there, as the buildings spread out along the streets, but the verticals are missing. There are no tall buildings here. My vision is not so interrupted. When I stroll through the streets, I let my footsteps hug the buildings. Very flat, everything is very flat. I end up staring intensely at the cement between the bricks. I think of Matta-Clark's odd lots that he accumulated in the seventies, all of them very flat indeed. All this flatness and broadness must have inspired him."

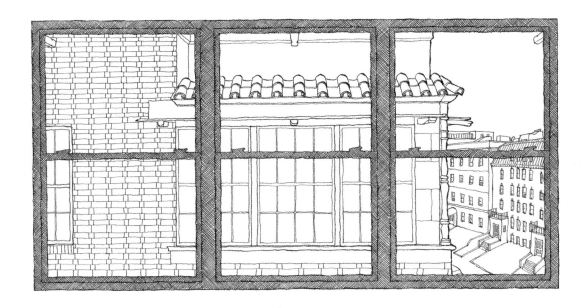

ISIDRO BLASCO

"My writing desk is kitty-corner to the window in this picture, and during the day, when I turn my head leftward and look outside, I'll see across the street, to the parallel apartment building on Twenty-first Street. That building is on the north side of Gramercy Park, and it's obviously expensive as hell to live over there, this beautiful brick jobber with large wide windows where the panes are crossed with a crochet of fancy-looking smaller frames. A lot of the time, a flat-screen plasma TV is on in the apartment across the way from mine and I can see whatever movie or program is playing. But the times that I think are most representative of me and my view from this desk are times like the very moment that I'm writing this—when it's the middle of the night, and the lights across the way are off, and as I sit here trying to figure out a paragraph, when I turn to the window, the only things I see are a reflection of light from my desk lamp and an outline, faintly, of my own face."

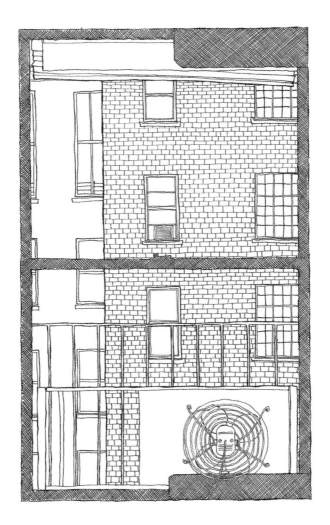

CHARLES BOCK

"When I sit at my desk, I'm very aware of the sky. From thirty-four floors up, I can't hear the traffic on the ground, but I can see the traffic in the air. My window faces east, toward LaGuardia and Kennedy, where I'm usually flying in or out every week. The sky links me to Berlin and Cairo and Freetown and the world out there. That's where my mind's at when I'm working."

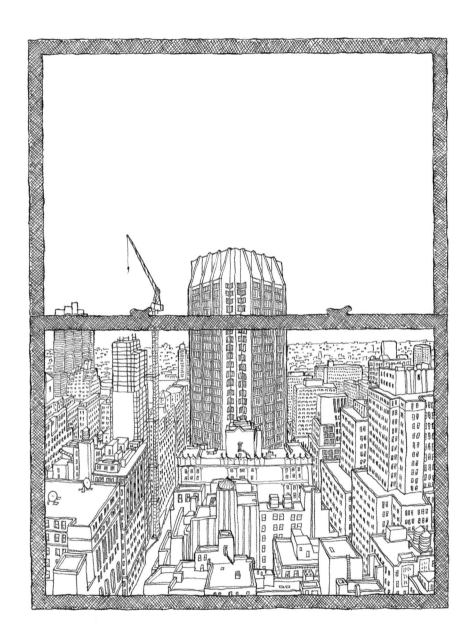

CARROLL BOGERT

"I think of my view as pretty typical for a New Yorker. We look out our windows at other windows. That, in a way, mirrors our lives here—we are constantly looking at each other, millions of us, on the streets and elsewhere. I know a couple of the people behind those windows across my street, but I keep my blinds up most of the time anyway. We pretend not to look. This allows us to keep the blinds up and let some light in. I've been to places that have 'better' views. I sometimes have view envy, especially now as I see hundreds of luxury condos going up everywhere—all of them with better views than mine. I suspect that most of them will remain empty in the near future, as who can afford them anymore? Maybe those glass towers will be the new homesteads—cheap artists' housing, but I doubt it."

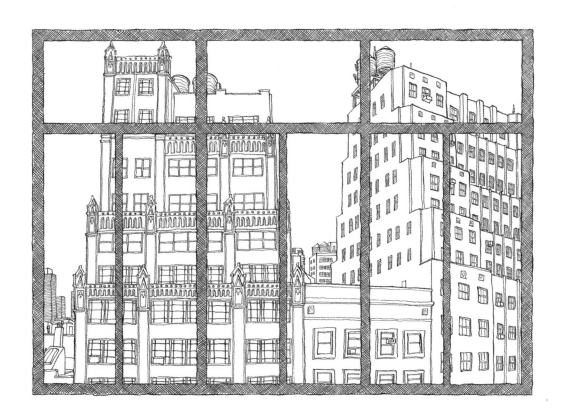

DAVID BYRNE

"I can see dead people out this window, by my desk. For instance, the famous showman P. T. Barnum passes along Broadway, on his way to arrange the wedding of Tom Thumb to Lavinia Warren, the 'Queen of Beauty.' Mme. Demorest, who lived next door to me in 1863, would make the wedding dress. That is, in 1863 the tiny Lavinia Warren stood on the other side of my wall.

"Peer over the window ledge, Your Majesty. You have the same view I will have in 2008, more or less, close enough. In truth, the building on the right in the drawing (you can just see its high northern wall) was a narrow theater. Christy's Minstrels played there from 1847 until 1854. Black and white minstrels—God Save America—thirty seconds' walk from my front door.

"The building next door, the one behind the head of that wooden bird, was by Bartholomew Delapierre. The building next to it did not exist. I can see the building that stood there before it. I can see the whole damn thing on fire. I can see Robert Maynicke's 1902 design for a loft for lace makers. That's it there, with exactly five huge windows on each floor. This farsighted plan meant that, in the weeks before the 2008 elections, our neighbors could cut out large three-foot-high letters to occupy the center of each frame. O-B-A-M-A.

"It's a fine view for a writer, to see the unimaginable imagined, a good way to start the day."

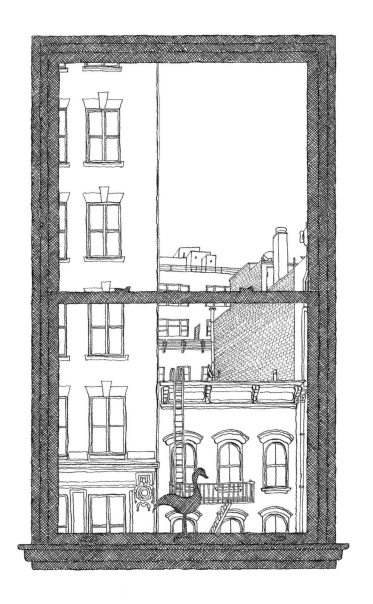

PETER CAREY

"The view from my office chair is typically filled with fields of Times New Roman type receding in evenly spaced rows. They seem to go on forever. But if I turn my chair to the right, the panorama outside my office, which occupies the southeast corner of the Condé Nast Building twenty-two floors above Times Square to the west, is even more spectacular. At the far end of the Forty-second Street canyon I can see the East River flowing by and—on particularly clear days—all the way to Gantry Plaza State Park in Queens. To the south, the exquisite crown atop Helmle & Corbett's Gothic Bush Tower soars at eye level. To the north, the newly finished Bank of America Tower—with its Escher-like slopes of glass and steel—reflects its neighbors until nightfall, when the building's exterior dissolves to reveal a glowing hive of bank employees updating their résumés. Between this striking urban frame, Bryant Park, to the back of the New York Public Library, is home to a neatly boxed grove of trees. And its great canopy moves swiftly through the seasons to the apparent amusement of the library's Vermont marble Beaux-Arts facade. 'Patience' and 'Fortitude'—as the building's pair of unflinching stone lions flanking the Fifth Avenue entrance are called—would rather, like me, look to the east."

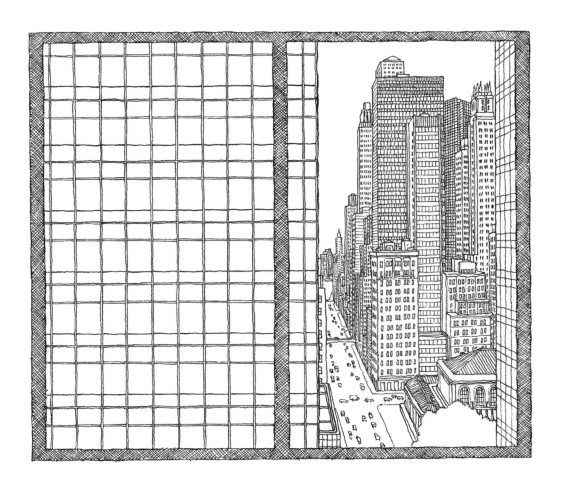

GRAYDON CARTER

"I looked at a lot of brownstones in Chelsea before we found this one, and it was one of the few that had the original moldings still intact on the parlor floor. That was a huge selling point, but it wasn't enough to seal the deal for me. This view, from the master bedroom window, made my heart melt. The top of the Empire State Building peeking over the high-rise landscape from our southwest perspective, with the south side of the Chelsea Hotel rising in back of the brownstones across the street, spoke to me of every-thing I love about New York. I love to see the changing colors on the top of the Empire State Building, and the soft hues add a lot of romance to our room. My husband and I have close friends who live in the Chelsea Hotel, and they can look out their window and see our bedroom. Whenever I visit them, I can look at my own window from their apartment and see the reverse of my view."

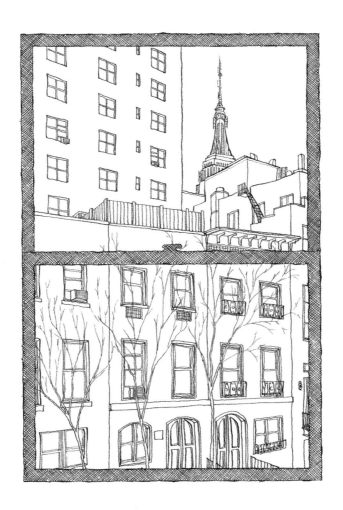

ROSANNE CASH

"Because my studio is directly across from a windowless telecommunications skyscraper whose peak bristles with microwave transmitters, when I think of my view mostly I think about cancer, so I try not to think about it at all."

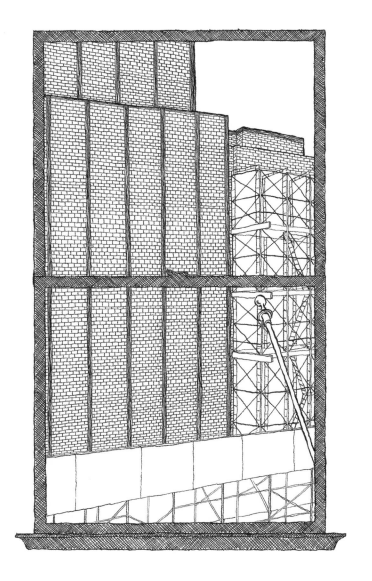

STEPHEN COLBERT

"I wear my reading glasses while I work, not my distance glasses, so the world I see through this window is usually fuzzy. That's ideal. I don't want to be distracted, but I like the reminder that I'm located somewhere particular—in this case, southern Park Slope, Brooklyn. The window faces south, and since all the buildings in our neighborhood are low to the ground, it gets sun all day, when there is any. Unlike painters, I'm not subtle about sunlight. I like it to hit me directly. The ladders in the picture are towers for attaching the far ends of laundry lines. Some look as old as the buildings, which date from the turn of the last century. In idle moments, I wonder if ours is still sturdy enough to climb, should Peter and I ever decide to dry our clothes the old-fashioned way."

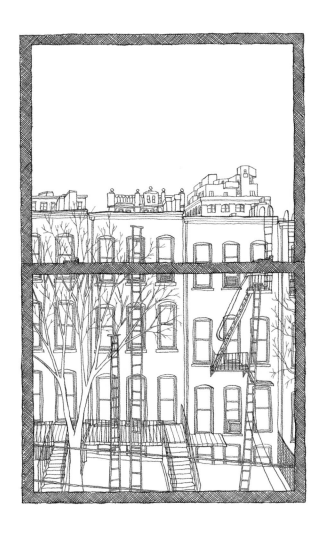

CALEB CRAIN

"I rarely get a chance to write about architecture, but it was through the architectural writings of Rudolf Wittkower that I first learned how to think about art. Actually, one of the first pieces I ever wrote on art was about the building seen through our window. I was interested in the fact that it is twelve stories high, like our building, and that the architect, trained in the Beaux-Arts tradition, had to figure out how to design a building that tall. There was a demand for buildings of this height early in the twentieth century, and it was now possible to lift elevators that high because the subway had brought power lines up to this neighborhood. I loved the fact that the building is a variation of the Palazzo Farnese in Rome—notice the rustication and the ornamentation of the piano nobile. Then *zip!* the body of the building is about nine stories high. At the top, there is another Italianate structure. All the buildings of that era are a product of real estate, electricity, and Beaux-Arts architectural values. The building is nicely set back, so it does not block our view of the park. We are just low enough to take in the street life: dogs, schoolchildren, taxis, skateboarders."

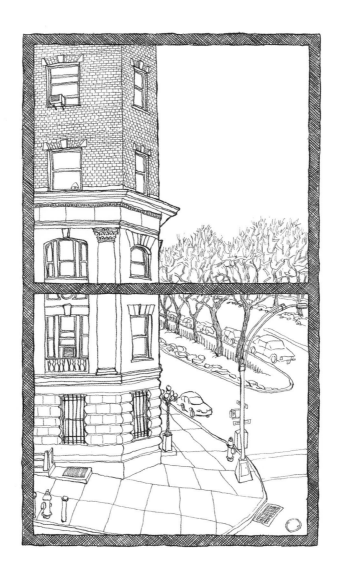

ARTHUR DANTO

"Ten years renting the same Brooklyn apartment—a record among my peers—and I still have a bedroom/office. This is the view from my desk. It's the window I lean out of when I sneak cigarettes. I never lower the blinds. In the summer, the tree offers privacy, and as winter comes, I lose it. The windows of my Indiana youth were quiet except for weather. Here, I can hear kids playing on the caged playground deck to the right, traffic humming somewhere on the other side of those buildings, my neighbors drinking beer in their gardens at dusk. I smell barbecues and fireplaces and trucks. That's an ailanthus tree, by the way, the *Tree Grows in Brooklyn* tree. Through my living room windows, in the front of the house, I've seen the neighborhood change. But this fire escape patio, these stairs to the roof, that tree: my own piece of Brooklyn has stayed the same."

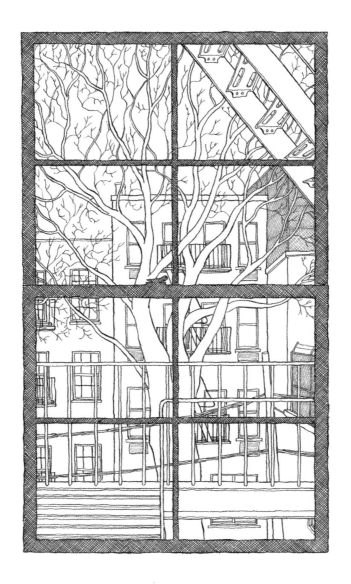

MATT DELLINGER

"Up here windows are not windows; they're more like peepholes. *Rear Window* without any of the architectural or human splendor."

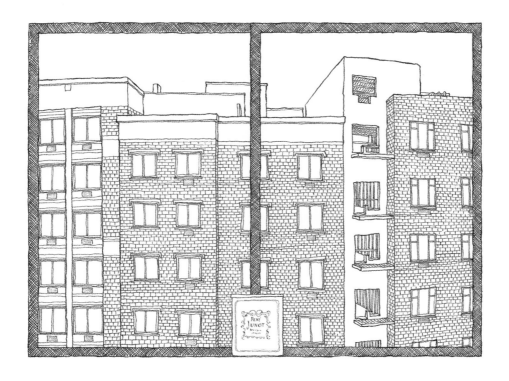

JUNOT DÍAZ

"This is my archaeological view, the buildings closer to the ground dating from the twenties and thirties, then the loftier bulkier examples of the postwar boom, and finally the arrogant sky-poking towers of the late twentieth and early twenty-first centuries. A totally chaotic cityscape, mysteriously coherent. And sailing through its alleys of air is the Roosevelt Island tram, which from this distance seems like a children's ride over a fairground. But what I'm most thankful for is the expanse of still available sky."

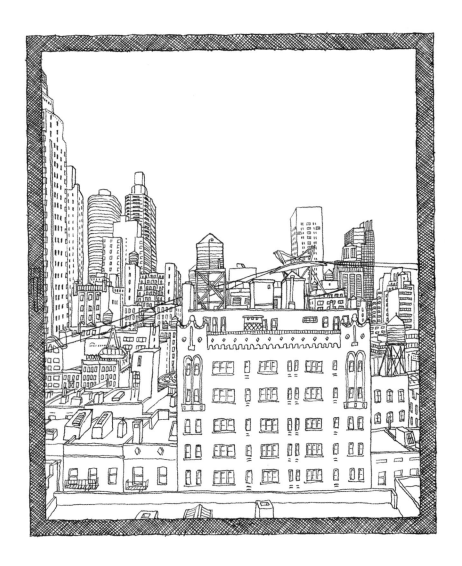

E. L. DOCTOROW

"I'm just happy to see sky. I really never take it for granted. From that window, you can see the tip of the Empire State, and the peak of the Chrysler Building, both of which light up beautifully at night. Over the years, I've learned you can catch the fireworks in Central Park during the summer, but only ever the finales—those are the only shells they fire high enough to clear the buildings nearby. My favorite New York feature, one of the things I'm most attached to, is the wooden water tower. There's one on every roof. And I look out on a bunch. When I first moved to the city, a friend pointed them out as things of great majesty. He was obsessed with them. I'm not sure I would have noticed the water towers without help, or that I'd have decided they were some kind of wonder. But I've long since come to agree. Now I wouldn't trade them for mountains in the distance. They are very much this city to me."

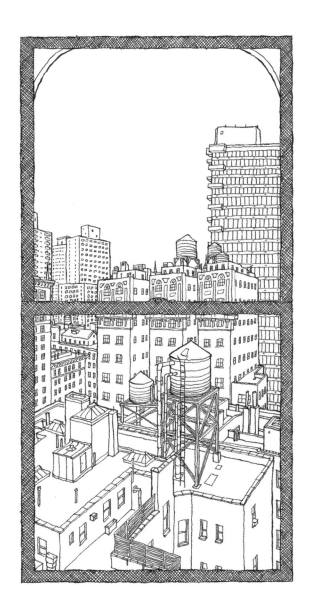

NATHAN ENGLANDER

"One of the things I can see through these beautiful Juliet windows in my office is the Chrysler Building. It's my favorite building in all the world, the absolute epitome of every glittery dream I have ever had about New York. Fortunately, when I write, I face away from it, or I would never get anything done."

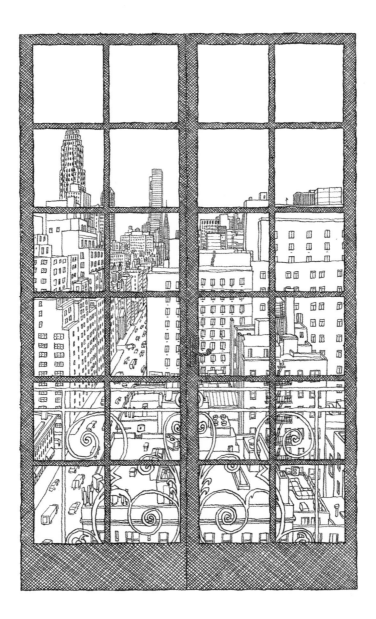

NORA EPHRON

"I like the grimness of it, like seeing the other wing of the madhouse across the alley."

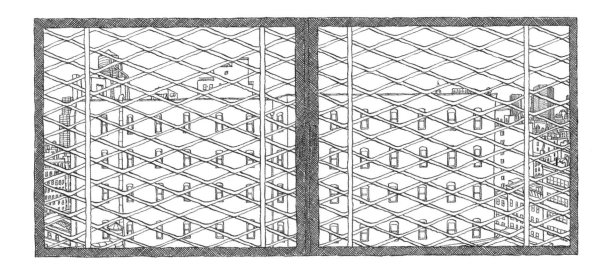

RICHARD FLOOD

"Little-known architect Stephen Decatur Hatch designed a masterpiece across the street from me. I am lucky to gaze at it every day through my window. Sometimes I imagine that I am living someplace far away, a city in northern Europe or in a castle during another time. I often think about the loss the inhabitants across the street must feel because they cannot see what I see. They are stuck looking at my rather undistinguished building and the others surrounding it. The eye can never see itself. Sometimes that is a lucky thing and sometimes not."

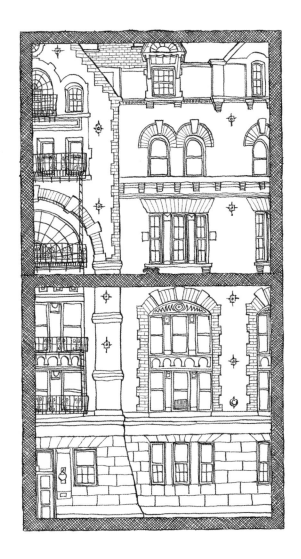

NIEL FRANKEL

"The garbage truck wakes you at 3:30 or 4:00 every morning without fail. If you open the window, the smell of garbage—yuck! The true picture of a mess in New York."

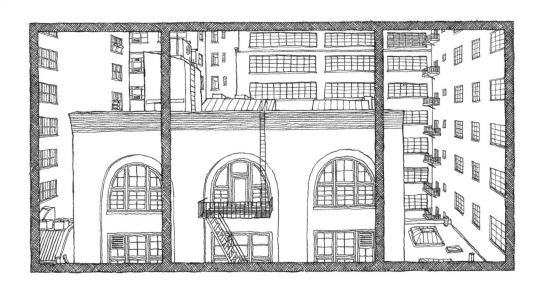

GELEK RIMPOCHE

"When I first moved to this studio, the window was covered with boards. As I removed them and replaced the window, I realized what a marvelous, comprehensive view this is of Lower Manhattan. From the 1760s Dutch church to the most modern buildings, it contains more than two centuries of architecture, images of which I've recently started to use in my paintings. It represents to me the endless activity and hopefulness that is life here in New York City."

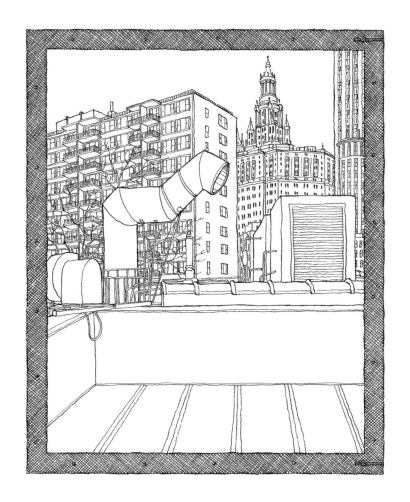

NICK GHIZ

"Water tanks, air-conditioning, and exhaust pipes. The infrastructure of New York in plain view. I love it!"

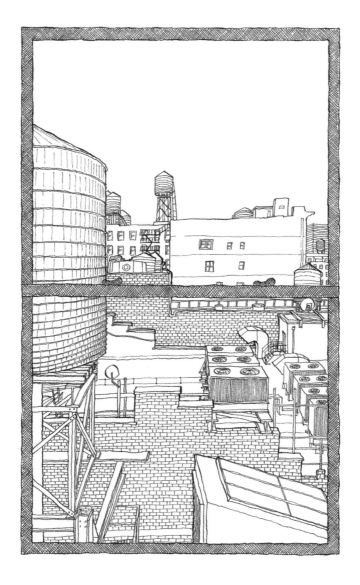

PHILIP GLASS

"The view from my desk shows my remove from the heart of the city. There's a sliver of the East River visible, Union Square beyond, and lots of sky. This corner was quiet like the suburbs in the nineties. An old man kept his pigeons in a coop on the roof next door. Now the view is shrinking, with high-rises going up along the river, and the low building two doors down adding a few floors and blocking out most of the river view. And the quiet is gone—construction during the day and half a dozen night spots (bars, music clubs, a beer hall) in a one-block radius. The city chased me down."

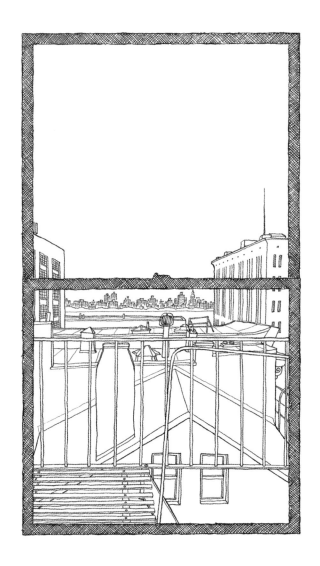

ETHAN HERSCHENFELD

"My window view allows the light to shine through unimpeded."

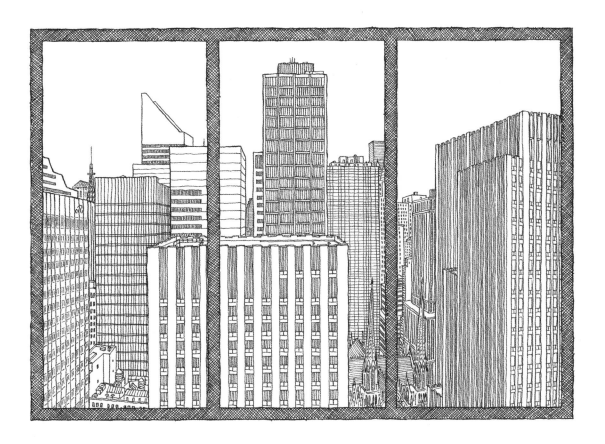

ED KOCH

"My son's bedroom looks out over the Brooklyn Society for Ethical Culture. All summer, the Ethicists rent out the garden for weddings: brass bands, drunken toasts, feedback, Can You Feel the Love Tonight, That's Amore, Unchained Melody filter through his sleep. A child's education in romantic cliché."

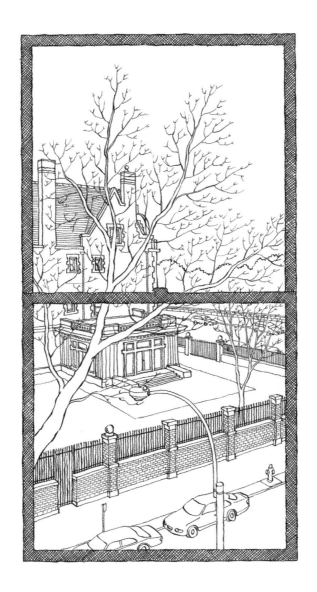

NICOLE KRAUSS

"I once had an apartment with a narrow view of the Hudson, and that was really splendid, but I moved. Our current apartment's higher up than any place I've ever lived; I've become a cliff dweller. I never thought I had vertigo, but the altitude, the vast canyon spaces between my cliff and neighboring cliffs give me a peculiar, heady, woozy thrill. I assume anyone who really loves Manhattan must find engineering erotic: grids, graphs, Euclidean geometry, right and acute angles; the way these lines, these inorganic arrangements of force, symmetry, and ambition slice and tussle with and trap the organic, the asymmetrical, the sloppy; the way the sloppy and soft struggle, joyfully and miserably, caged behind these bars, girdled within these frames. It's kind of S&M. But I miss the river."

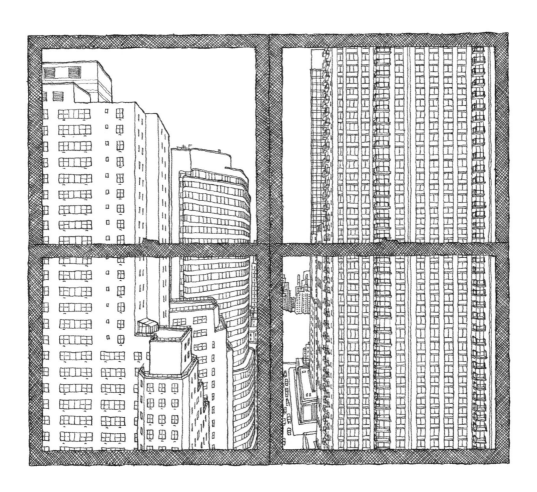

TONY KUSHNER

"When I first began living in my house in Greenwich Village, I thought I had no view on the ground floor. And then I noticed that at a certain time of day, a shadow slowly forms on the brick wall at the far side of the little yard in back. I can see it through the glass doors in the dining room. The imprint of a large sycamore tree growing in our yard takes shape on the wall. It's a borrowed view. A New York thing."

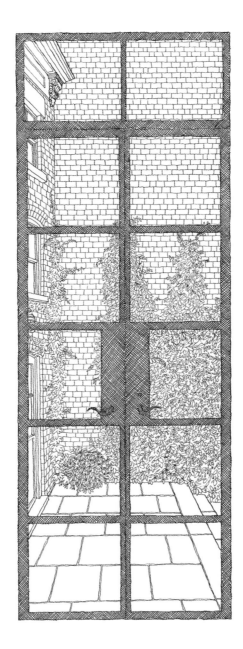

ANNIE LEIBOVITZ

"The view from my window captures the poetry of New York. It is full of emotion and geometry . . . and yet it is emotion which is at the core of architecture. What an inspiring theater of memory!"

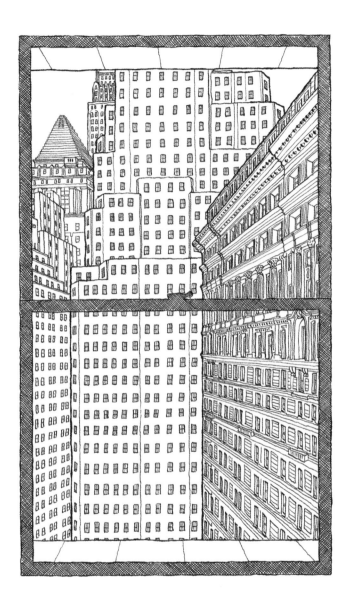

DANIEL LIBESKIND

"My writing office is on the third (top) floor of a brownstone where my wife, daughter, and I have lived for the past fourteen years. When I look out the window in summertime I am aware of a generalized green from several old trees; in autumn the leaves turn brown and fall off, and I can see much more clearly my neighbors' brownstones across the street. I've never put up curtains or window shades, and I am never sure how much my neighbors can see into my room, which is why I don't write at my desk in the nude (or not very often). Our block, which is in Carroll Gardens, is a quiet one and used to be 90 percent Italian, but now is more mixed-gentrified. I am glad the view is fairly mundane and not more breathtaking, as a vista too picturesque might distract me from my writing. The old expression for meditating is being in "a brown study," and the muddy cocoa backdrop of brownstone facades and stoops across the way permits me to stay in my thoughts, while I am dimly conscious of the lapping ambience of Brooklyn, the sounds of passing cars and the twittering leaves. It is as though I were cocooned in a tree house of my own. The muted colors outside my window are slightly blurred at the edges, like a Corot painting. On either side of my central window are bookshelves, and the spines of volumes by other authors, peripherally glimpsed, act as prods to keep me at the task."

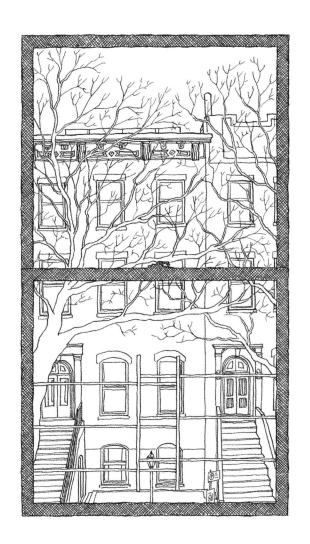

PHILLIP LOPATE

"My view is tempered by windows fritted with fine white lines, creating an almost diaphanous veil that softens the outlines of the museum's garden below me, and the apartment buildings across the street."

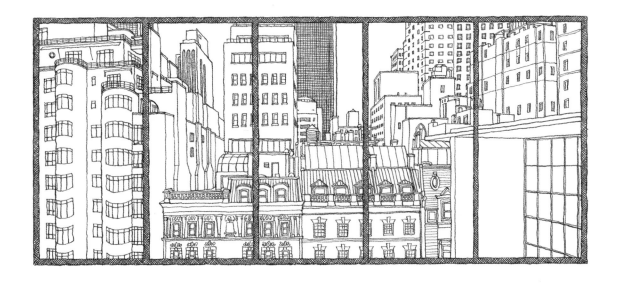

GLENN D. LOWRY

"We are urban folks; city life means much to us. However, having a view of trees and a serene courtyard where we can enjoy the changing views that come with the seasons—the colors of fall, the lights of the holidays, the buds of spring—provides a relaxing contrast to the energy of the city. Most important, this view comes with light; lots of light."

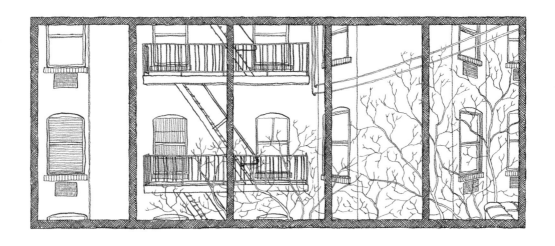

FRED LUBLIN

"The sun sets orange beyond that lower-right pane and everything is golden and aglow."

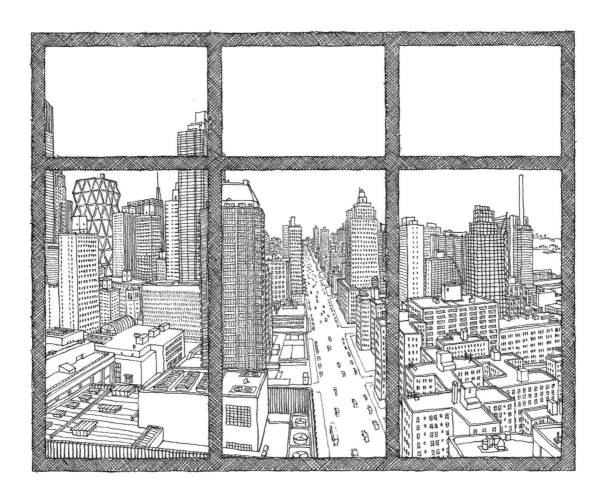

WYNTON MARSALIS

"This view has greeted me every day for twenty-eight years. It's sliced in half. The left half is a vertical slab of the south side of the undistinguished grayish brick 1909 apartment building across the street, its rows of identical windows staring blankly back at me because the blinds and curtains seem to always be drawn shut. It gives the eye no nourishment whatsoever. The right half of my view is horizontally sliced in half and offers a visual feast: ever-changing sky above, the screen of trees bordering Central Park below. You can see far to the east, where it's too far north for a glimpse of real Manhattan skyline except for the ugly brown stub of Mount Sinai Hospital poking up in the distance. Behind and beyond is a 120-degree background sweep taking in the tops of the few tall buildings that stand north of Ninety-sixth Street. Barely noticeable in daytime but forming a constant moving necklace of tiny red and white lights at night is the traffic coming into and flying out of LaGuardia Airport; when my window is open and the wind blows from the east, the roar and whine of jet engines accelerating for takeoff sounds frighteningly loud and close. So do the commuter helicopters overhead, shuttling all day to and from New Jersey. Trucks, buses, ambulances, police cars, fire trucks, motorcycles, and SUVs with open windows blasting hip-hop race up and down Central Park West twenty-four hours a day. These views and these noises barely enter my consciousness today, after twenty-eight years. I might as well be in Cleveland."

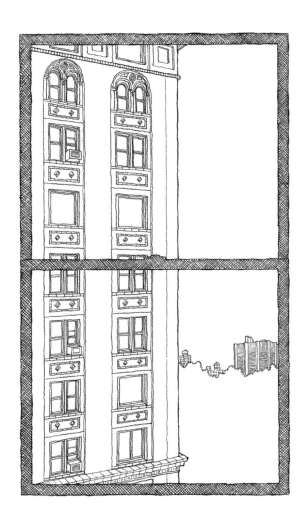

BRUCE MCCALL

"What we see out our windows is not always what others see. We must treat our windows like stories. I like to think that we can open them up to as many other stories as we want. So outside my window is Sarajevo, and San Francisco, and Sydney, and Saint Petersburg, and Dublin, where I first opened a window, and of course New York, where I continue to open windows. The mind leaps outward. We may look at a brick wall, or an air-conditioning vent, or a patchwork of iron bars, and find in them a series of mysteries. Once, I recall, a bird flew into my room. He bashed himself against the paintings that I had on the wall. He got out through the same window he came in."

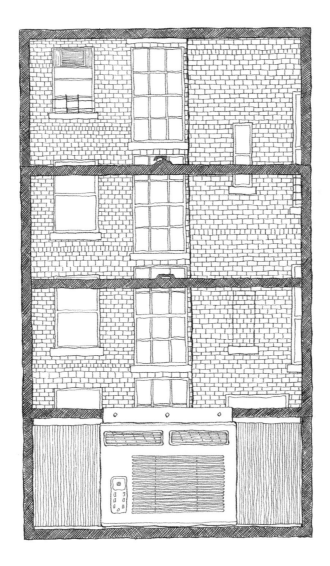

COLUM MCCANN

"The mullions on this window in my office—which looks east to the Empire State Building—were recently changed by the landlord, who wanted to 'modernize' the windows of the building. It was a heavy-handed gesture, but at night the view is still as glorious as ever."

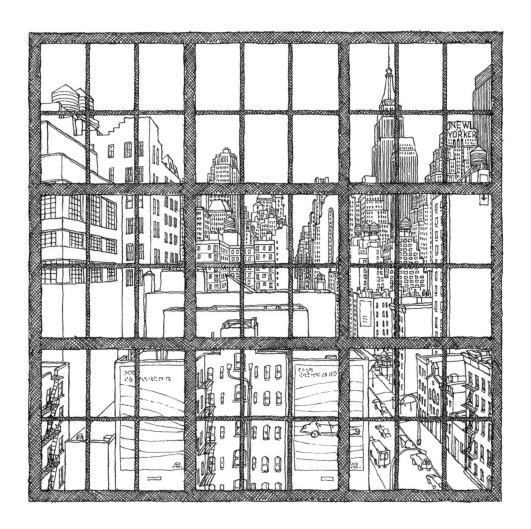

RICHARD MEIER

"Looking at this drawing has made me look at the view it shows as essentially a view of other windows. In this way it reminds me of people looking at other people. Each person looking out any one of those other windows is the master and commander of his view, as I am the master and commander of mine. Every window is literally and metaphorically a point of view, and everyone who looks out a window is a sovereign of what he sees. But each window, like each subjective consciousness, is also a barrier—it stands for the wall that keeps us restricted to our own selves. We can look at each other, even peer into the eyes (the 'windows') of each other, but we cannot dwell in each other. So a view, like vision in general, at once connects us to and separates us from the world and other people."

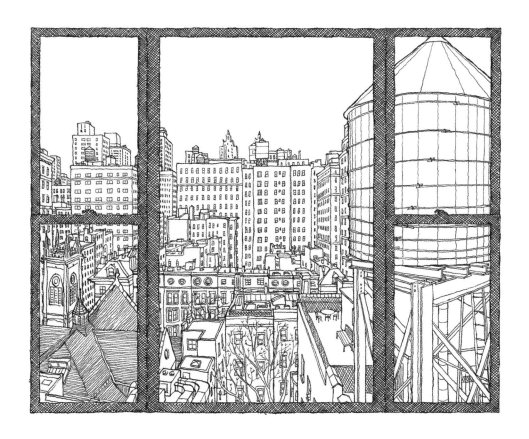

DANIEL MENAKER

"Every morning I say to myself that I wish I could be higher. But I know that I would say the same even if I were on the top floor."

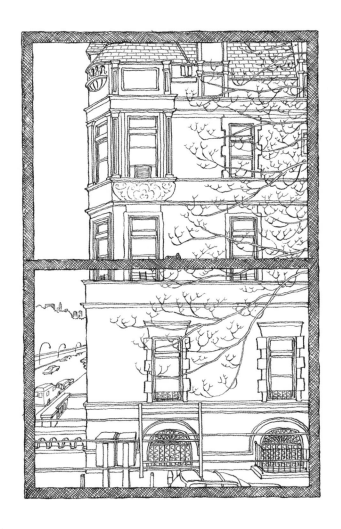

ANTONIO MONDA

"This is the Clock Tower Building. It was built in 1894 for an insurance company and it is a designated historical landmark. The facade was designed by Stanford White. It is now used by the city for Criminal Court. There are often fistfights and screaming matches in the alley, leading me to suspect that the court's decisions, not surprisingly, are not always well received. I once threw a friend's lit cigar out the window and it landed on a sleeping homeless man who subsequently caught fire, and many fire engines squeezed into the alley to extinguish the flames. He was not hurt, in part, a fireman told me, because his clothes were fire retardant. I was horrified that I had caused even the slightest burn, and we became friends (I give him a winter outfit each year, which I suspect is not inflammable). The particular charm of the clock tower is that it anachronistically rings the hour with loud peals. In the twelve years that I have looked out this window, the bells have never failed. I hear them while I am working and I hear them when I sleep."

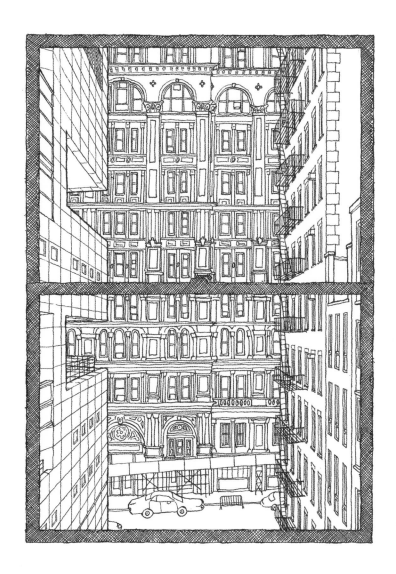

SUSANNA MOORE

"Here is what I see from my apartment window: the apartments across the street that, with alarming regularity, empty and then refill with new people who change clothes, watch television, and have sex in a variety of ways. Tourists at the top of the Empire State Building take flash photographs of me in my apartment. I wonder how they turn out."

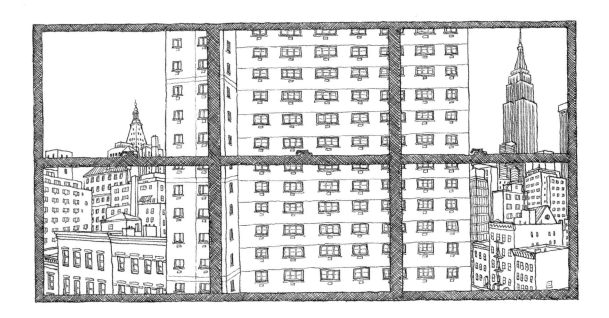

MARK MORRIS

"I can see this amazing Chinese apartment block; every morning, old women perform slow-motion martial arts in the courtyard. If I look left, I can see the Chrysler Building. When I first moved in, I could see the Empire State Building, but then people built a ridiculous hotel directly in the way, so now all I can see is the spire, gently illuminated from below."

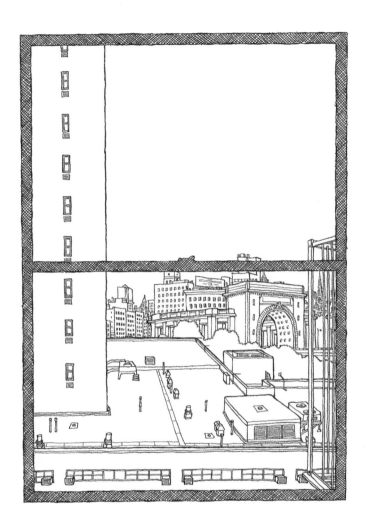

NICO MUHLY

"I've lived in New York (both Manhattan and Brooklyn) most of my life. This is my favorite view from any window I've ever had, though I once lived in a U-shaped apartment building, and it was very moving to be able to glimpse my family in the kitchen from my bedroom. A little like eavesdropping on your life. This view has an auditory component: the church bells ring periodically; they're not too loud, but serve as a gentle reminder of time passing. And the trees in the backyard of the house are very old, so they seem to creak in the wind and rustle and sigh. When I'm writing poetry, all this natural and man-made muttering can be an inspiration at times."

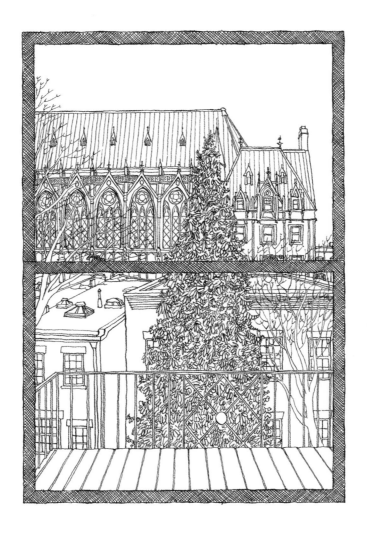

MEGHAN O'ROURKE

"What I require from a view out my studio window is just the right amount of interest, that is to say, not too much interest. I could never work in a cottage by the sea. How could I? I would always be out on the porch, enraptured by the beautiful face of the timeless waves. Ditto for mountains. No. I am happy to be ensconced on the fourth floor, in the back of my building, facing a quiet courtyard with about five trees, a handful of terraces, and numberless windows. Occasionally, if I really feel the need, I can yawn and stretch and then stand by the window to have a look-see at what my neighbors or their few cats are doing; perhaps someone is replacing their ratty deck furniture, or washing a window or even building a bedroom. It never really matters because in the end, I always let my eyes meander to the small polygon of changeable sky, perfectly framed like the masterpiece it is."

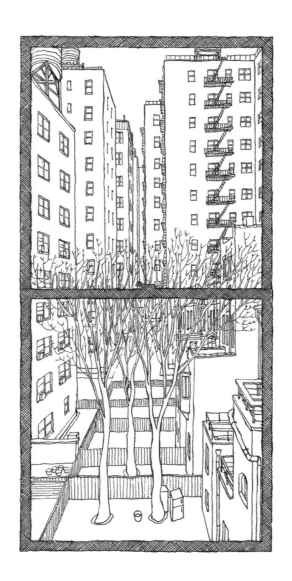

CHRIS RASCHKA

"The interlocking symmetries of the buildings across the way, the old brownstones with their stoops, the ginkgo trees which line the street—all this I find solid and calming. But looking down at this busy corner of Thirteenth Street and Greenwich Avenue, I also see and hear the constant movement and life of New York City—people hurrying, carrying bags, idly chatting or smoking, walking their dogs, parking their cars. Impossibly large trucks making the tight corner, noisy fire engines screaming by, the A train rumbling beneath the pavement. My typewriter desk sits in front of the window, so this is the view that faces me whenever I sit down to write. I think I need the ever-moving flow of city life as a counterpoint to my own thinking and writing."

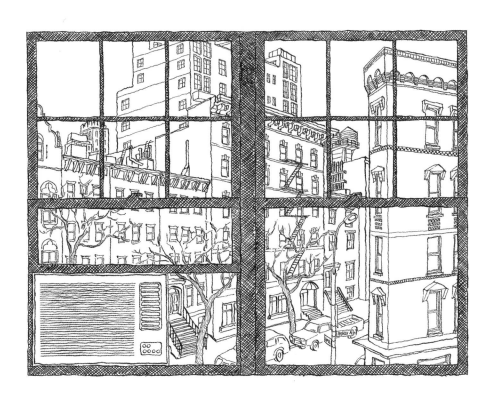

OLIVER SACKS

"When I returned to New York in 1993 I wanted to get a place capable of reminding all of us in the studio that we live in New York City on a daily basis. New York is the classic symbol for the modern city, with the Empire State Building, the ultimate icon, summing up all skyscrapers. As we tend to spend significant parts of our lives in the studio, the view keeps us connected to the outside world with the changing weather and light situations creating a lively and always different working environment."

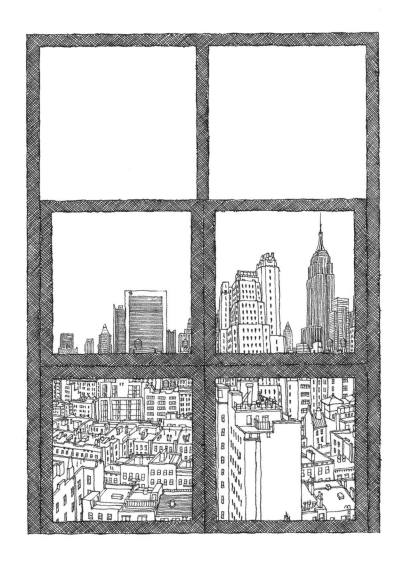

STEFAN SAGMEISTER

"I write on my couch or in my bed, and when I look up from my work I see the distant skyline of New York's financial district, bracketed by the magnificent Gothic crown of the Woolworth Building and the gargantuan glass-and-aluminum block of the Chase Manhattan Bank Tower. These days, I speculate on the financial disaster building in the narrow streets—how strange that America's capitalist demise is headquartered within my sight. And closer to me, right below the canopy of skyscrapers, some short redbrick housing projects beckon with Latin music and happy shouts in the night, reminding me that there are many New Yorks, at least one of which I love."

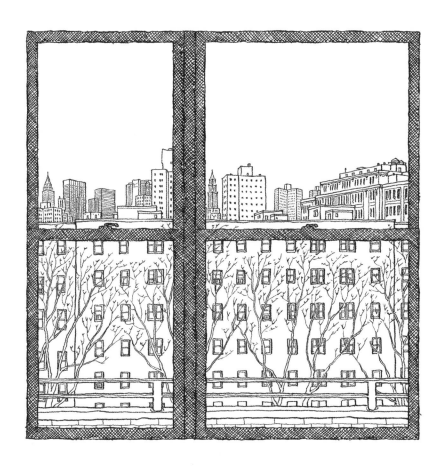

GARY SHTEYNGART

"When I am drawing pictures for a book over many weeks or months, it is nice to look outside and see the real world. The models and junkies and kids from the Catholic school across the street. The dogs—one of them has a set of wheels instead of hind legs—romping by. What have I seen from my window? Marching processions and bands with statues of Saint Anthony or San Gennaro; lots of car crashes because of a silly stop sign on Elizabeth Street; lots of bums, transvestites, and panhandlers from the Bowery, the next street to the east. The transformation of a bodega, a hardware store, and a shoe repair shop into boutiques and more boutiques. Dustin Hoffman shopping, the owner of the Connecticut Muffin café shot to death, an old Italian lady sitting on her chair outside the Albanian butcher shop. Martin Scorsese grew up in that building and slept on the fire escape on hot summer nights. After years of emptiness, the greasy spoon just below my kitchen became a trendy café, the Cafe Habana. Condo buildings are growing like mushrooms now, and old wrinkly artists of the past are disappearing. The pigment store under my studio became a handbag boutique. I will have to draw with markers now."

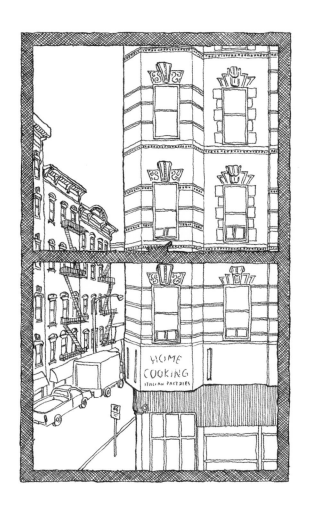

PETER SÍS

"It's a southwest-facing window and that means plenty of sunlight, a rarity in this city. The lower part of the view shows the rooftops of the small nineteenth-century houses that line West Seventy-sixth and Seventy-seventh streets, a view pretty much unchanged since the time our building went up in 1927, and that is very pleasant. In the near distance is an apartment building contemporary with ours that has the merit of featuring an old-fashioned wooden water tower. Fortunately for my wife and me, the modern buildings of Donald Trump, with their ugly fenestration and hostile immensity, figure only in the distance. The glory of our view is the lordly, moody Hudson River, much reduced here in the middle right. For the twenty-seven years of our marriage this has afforded us sunsets that on some days are spectacular, on others merely beautiful."

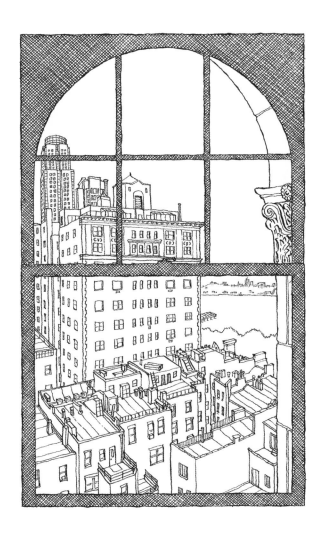

BEN SONNENBERG

"Most of my friends live in tiny apartments, but mine is the smallest. It holds a desk, a bed, and two straight-back chairs, but there is nowhere for instance to eat. Even the view is small. My neighbor across the courtyard (the one whose window you're looking into) works nights, in a restaurant. If I'm at home during the day I often hear him playing symphonies and singing—not humming, really singing, along. Twice I have had to scare strangers off my fire escape. Luckily I have nothing worth stealing. And now they've put up one of these big new condos next door, it looks like a twenty-three-storey stack of aquariums, only with people instead of fish. If I were a burglar it would certainly deter me. The other thing I should say is that Matteo inspired me to wash my two windows and screw in a pair of wooden blinds, and in yet another case of life imitating art, thanks to him, this view (which when he drew it I always kept behind dirty curtains) has for me become a source of great pleasure and well-being."

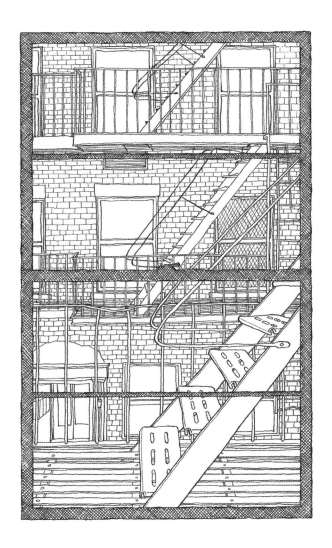

LORIN STEIN

"'What great light you have!' is often the first reaction of people seeing my office for the first time. Light does, in fact, come pouring in. I have fifteen-foot floor-to-ceiling windows looking south onto a quadrangle of the Columbia University campus. I can see a tree and, if I stand up, a statue of Thomas Jefferson, and, especially in the afternoon, I am flooded with light. The truth is, most of the time I hate my view and all this light. In the afternoons—especially in summer but even in the coldest days of winter—the sun comes pounding on top of my head. In the warmer months, between the hours of two and four, my brain seems to melt and I am literally incapable of thought. To combat the light, I have two sets of shades. One of them is a heavy, black matte shade that allows no light at all. And during most afternoons, I pull it all the way down and work in cavernous darkness with artificial light. So, I spend a good portion of my time in this office fighting the view, fighting the light, and doing my best to ignore them."

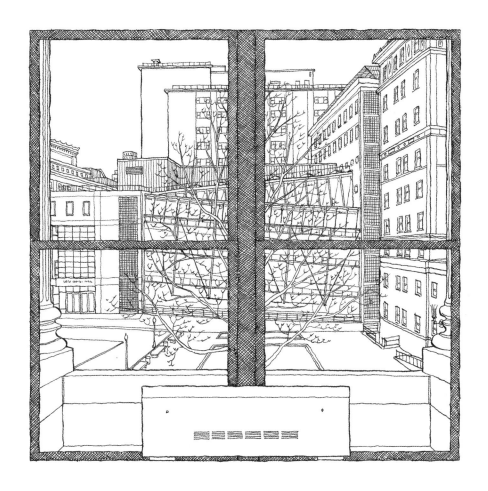

ALEXANDER STILLE

"As the lights begin to come on and the sky darkens, it seems a magical ocean appears—of air, of water; it hardly seems to matter—it is an ocean with its own magical twinkling stars. And yet each 'star' represents people. I love that."

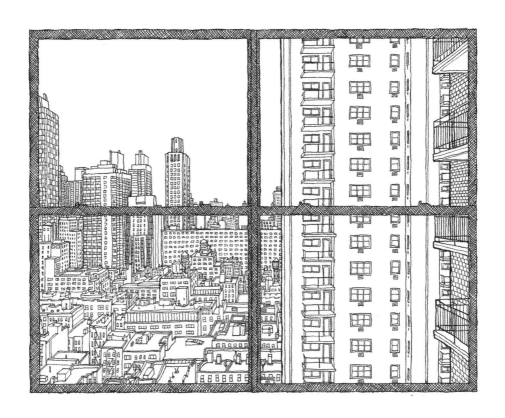

ELIZABETH STROUT

"I peer through state-of-the-art, ultraclear glass revealing wonderful, old New York with its majestic Empire State Building, a constantly bustling garment district, and an Eighth Avenue hurrying uptown."

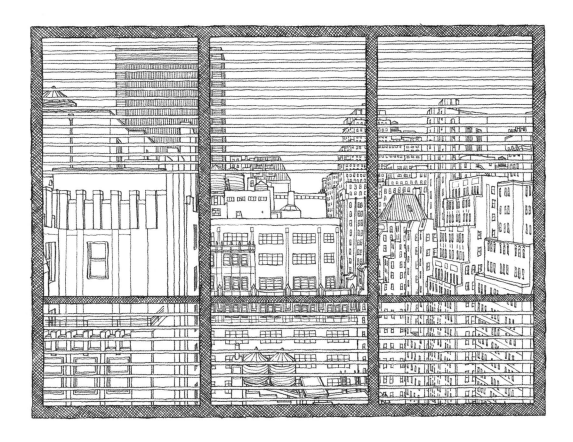

ARTHUR OCHS SULZBERGER JR.

"While glancing through the fourth-floor studio window of my brownstone in mid-Manhattan I have at best a murky view of my neighborhood due to my longtime avoidance of window washers.

"Many years ago, when I occasionally did employ window washers, the men would never arrive on time; and hours later, after I had finally gotten back to my writing, my concentration would be interrupted by the doorbell and then by the men's heavy breathing and grumbling as they climbed the four flights of steps with their buckets—and finally, after they had opened the window to wash the front part of the pane, they would flatten with the soles of their boots the rows of upright nails on the ledge that had originally been cemented there by a pest control crew to prevent the roosting of pigeons.

"And so now the noisy pigeons have regained their visitation rights to my ledge, and my window is darkened with dirt and bird droppings, and my view of the outside world is rather opaque and opalescent, like a Monet painting, and it is difficult for me to describe what I see since so much is left to my imagination."

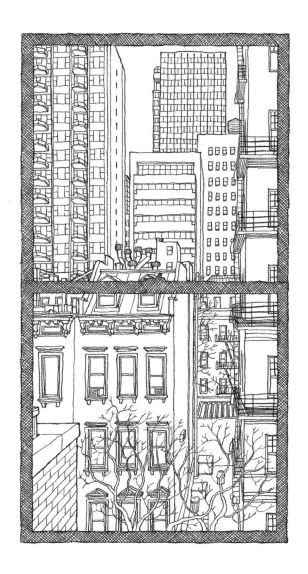

GAY TALESE

"There is always an inside and an outside. And there is always a boundary separating the two, even if we pretend otherwise. Sometimes it is as thick and stubborn as a brick wall. Sometimes it is as thin and immaterial as the visual field, or the limits of our imagination. I often wonder: Does it belong to the inside or to the outside? Is the boundary between me and the rest of the world a part of me, or is it out there? I don't know the answer. But I love my window and keep looking at its glass, for it reminds me that the question is an important one."

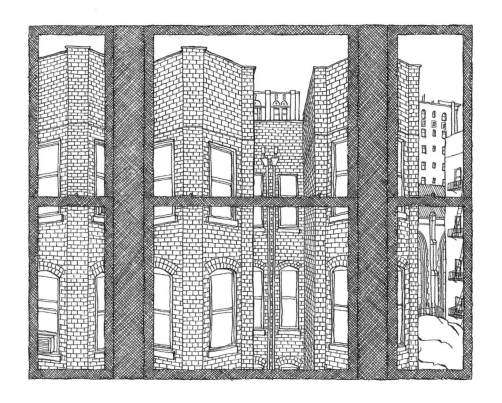

ACHILLE VARZI

"The water tower, of course, like a finial on a lamp. And the rooftops leading to the sky. Many of the windows have shades that are drawn, giving them a quality of dormancy. I see only one figure with any regularity, a famous man who sometimes sits at night in a room in which there are collections of his awards on the wall, like diplomas in a doctor's office. The room is softly lit. I have read that there are twenty rooms in his apartment, so there must be some reason he chooses so often to end the day in this one. On nights I stay up late I sometimes see him pass like a shadow in front of the windows and then the light in the room go out. The apartment was sold and the room where he sat is now a child's bedroom with, so far as I can see, nothing on the wall. I hardly ever look over there anymore."

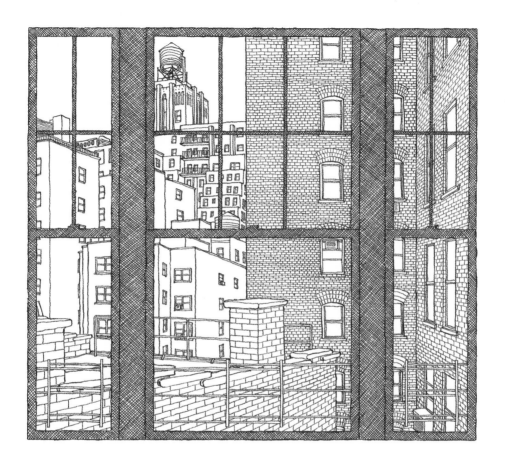

ALEC WILKINSON

"A real estate agent had shown my wife and me thirty-four apartments before we finally took the one you're looking out of right now. When we had reached twenty-nine she said to me, 'Do you realize that every time I show you an apartment, you never look at it? You rush straight to a window to assess the view.' To this day, I haven't really seen this apartment, only what's outside of it."

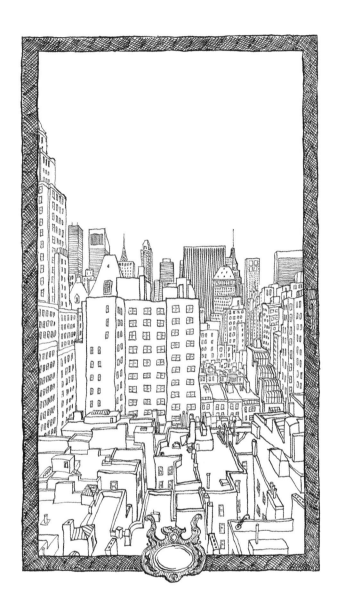

TOM WOLFE

"In a city with so much going on, it feels calming to come home, look out the window, and see the Hudson River. I'm not sure why, but looking at a large body of water seems to do that. I don't know how much longer we'll have this view. In New York City it's only a matter of time before someone builds in front of you, but we've been lucky enough to enjoy our view for ten years, and have hopes it will last a bit longer."

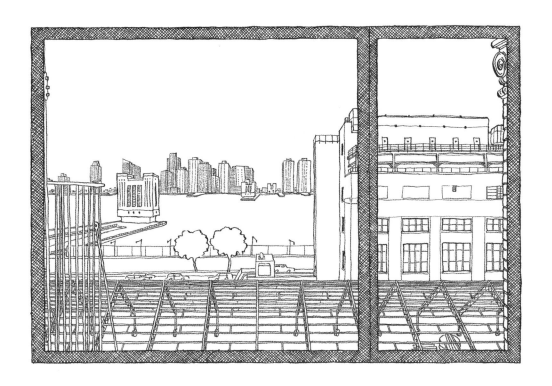

ADAM YAUCH

"The view out this window represents both the history and the future of New York City. We are on the nineteenth floor. Downtown, that is high up.

"Our legally mandated, soot-covered window guard reminds us that our kids are still small. We worry that we'll never feel safe opening up the windows wide, from the bottom, no matter how old the kids get. We also have a big terrace, which of course is a danger all the time, so that fear is pretty unfounded.

"This window is in the kitchen, the highly trafficked nexus of work space, leisure space, and general gustatory enjoyment. We look out this window a lot, at all times of day and night, in all kinds of moods.

"We can see the Great Hall at Cooper Union. Barack Obama spoke there this past fall. Before they were elected, Presidents Lincoln, Grant, Cleveland, Taft, and Theodore Roosevelt also spoke there.

"We see an iconic Manhattan building, the annex to the Wanamaker department store, which a hundred years ago was dominant in its industry. Today it is home to defunct dot-com offices and a Kmart.

"The tenements of my grandparents' Lower East Side and Brooklyn roots are being built over by shiny apartment towers that people like us will live in. We love looking at construction cranes."

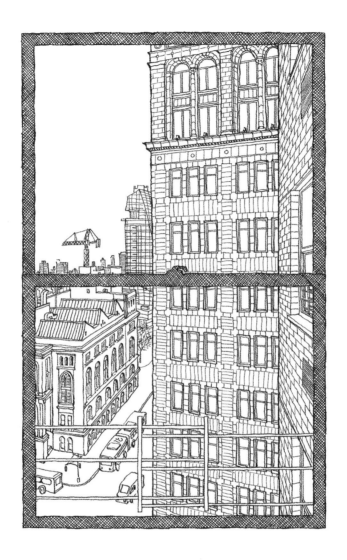

LAUREN ZALAZNICK

AFTERWORD

In the spring of 2004, my wife and I were getting ready to move out of the apartment on the Upper West Side of Manhattan where we had lived for seven years. During those years I spent large portions of my days in a room that served both as my studio and as our bedroom, transitioning seamlessly from sleep mode to work mode. As the days went by—and as I kept shifting things from the desk to the bed and vice versa—I would mechanically pause every so often and look, for no particular reason, out my window.

The view we had was a simple one—some low rooftops flanked by taller buildings (the ones along Riverside Drive and West End Avenue), with the steeple of Riverside Church to the north. It was like a canyon, punctuated by water towers.

One day, when our boxes were almost all packed, I remember looking once again at the view and was struck by a bewildering feeling of loss. "I can't leave this behind!" I told myself. Trying to understand my own sudden fear of separation, I estimated that in those seven years I must have spent roughly 640 hours, i.e., a period of more than twenty-six 24-hour days, staring at the view. I thought, "How great it would be if I could capture the view by simply peeling off an imaginary thin film from the glass, rolling it up, and then taking it to our new place."

In the end, I decided to photograph the view from all possible angles and perspectives within the room. But photographing the view meant photographing the window frame, too, for there is no such thing as a "window view" without a frame. That particular hole with that particular size and frame (our window), placed in that particular location in our wall, at that particular height from the ground, created—like a camera obscura held high up in the sky by some intricate scaffolding—that one and only arrangement of New York City landscape. And only by drawing it could I merge into one single *frame* all of those perspectives.

Having completed the drawing of my view, I found myself pondering views in general; to think, every view from every window in the city—with its own arrangement of other build-

ings, rooftops, skyscrapers, water towers, etc.—was the only one in the world! And to think, each of those views might have affected its "owner" the way mine had affected me.

"What if I could draw them all?" was my first, irrational thought. I couldn't, of course, but my quest led me to more than a hundred apartments, offices, and studios out of whose windows I looked and photographed. I also looked for people who would have a strong connection with the city—through their lives and their work—so that *their* New York would be even more meaningful. Sixty-three of those views are included in this book.

I always thought of this as the "invisible" New York project: a collection of views that one can see only by inhabiting, for a moment, someone else's brain.

Saul Steinberg, whose window view is on the cover of this book, was my first obsession within the obsession. His view had to be part of the book, because his drawings, more than anybody else's, show us *how* to view this city.

As it happened, his was also the most challenging view to document. With the help of the Saul Steinberg Foundation and a few of his friends, I found out where Mr. Steinberg's last studio was located, only to be barred by the super, who categorically refused to convey my request to the current owners. No doubt it struck him as peculiar—as an invasion of their privacy. I happened to learn that the apartment was on the market. I made an appointment with the real estate agent, who kindly agreed to let me in with her to take a picture of the view. But it was no good: the super, firmly guarding the building's entrance, recognized me and turned me away. In the end it was my wife and a friend of hers who managed to infiltrate the building as prospective buyers and photograph the view.

I mentioned privacy above. In several cases, people who declined to participate in this project gave a reason that almost made me happier than a yes. It usually went like this: "I am sorry, but I would rather not share a personal aspect of my life." Which seems to me perfectly understandable and right. After all, what lies beyond that thin sheet of glass mounted on our window frame belongs to our inner selves, and not to the outside world.

MATTEO PERICOLI, MARCH 2009

ACKNOWLEDGMENTS

I would like to express my gratitude to all of the people who let me into their homes, studios, and offices and allowed me to photograph their views. Not all of them, unfortunately, for one reason or another, made it into the book. I would like to thank them for their availability and kindness, for their written contributions, for introducing me to more views, and for their enthusiasm.

I would also like to thank the many other people who were crucial for suggesting views to include, for putting me in touch with their owners, or in some cases just for trying very hard. They are: Nicole Aragi, Mike Bellon, Steve Bodow, Amy Cole, Suzanne Daley, Raffaella De Angelis, Thierry Debaille, Kate Edgar, Sarah Fargo, David Foxley, Mary Garrigan, Claire Howorth, Violaine Huisman, Rochelle Katzman, Zoe Knight, Kathy Laritz, Owen Laster, Pamela Lewy, Matt Lieber, Amy Lloyd, Charles Luce, Livia Manera, Crystal Miles, Arthur Moskowitz, Karen Mulligan, Eva Nichols, Katherine Profeta, Matthias Oppliger, Cristopher Peregrin, Alisa Regas, Andrew Russell, Eliza Ryan, Sheila Schwartz, Hilary Siegel, Drew Smith, Joe Shouldice, Jody Smith, Nina Stern, Genevieve Stewart, James Trimble, Eleanor Wallace, Mary Watson, Lucinda Weaver, Anthony Weintraub, Sheila Wolfe, and Dechen Yauch. A very special thanks to Lorin Stein and Achille Varzi. Should I have forgotten someone, I apologize. Throughout the entire project, my wife, Holly, supported me and the book idea (even when I had only one view drawn, ours) with suggestions and practical and moral support that still amaze me.

I would like to thank my editor, Amanda Murray, together with Kate Ankofski, Larry Pekarek, Denise Roy, and the staff at Simon & Schuster, who have followed and cared for the publication of this book in the most heartwarming fashion. And Mary Lapegna of Toppan Printing and Pat Goley of Professional Graphics, who were indispensable to the book's production.

And, finally, I want to thank the two wonderful people without whose help, expertise, and enthusiasm this book would definitely not have happened: my agent, Tracy Fisher (who grasped the idea the moment she saw my first sketches), and her assistant, Elizabeth Reed.

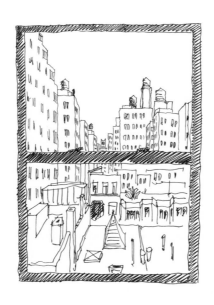

SKETCH OF MY OLD VIEW